An Atalanta Fugiens Coloring Book

Michael Maier

An Atalanta Fugiens
Coloring Book

50 emblems from the
original 1617 publication

Andrew Thomas Kuster

New York, New York

Emblems taken from *Atalanta fugiens: secretioris naturae secretorum scrutinium chymicum* by Michael Maier (1596–1622), engraved by Johannes Theodorus de Bry or Matthäus Merian, published by the heirs of Theodor de Bry, first published in 1617.

Andrew Thomas Kuster, New York, New York 10001

ISBN: 978-1-71694-236-5

Revision 2007-06-24

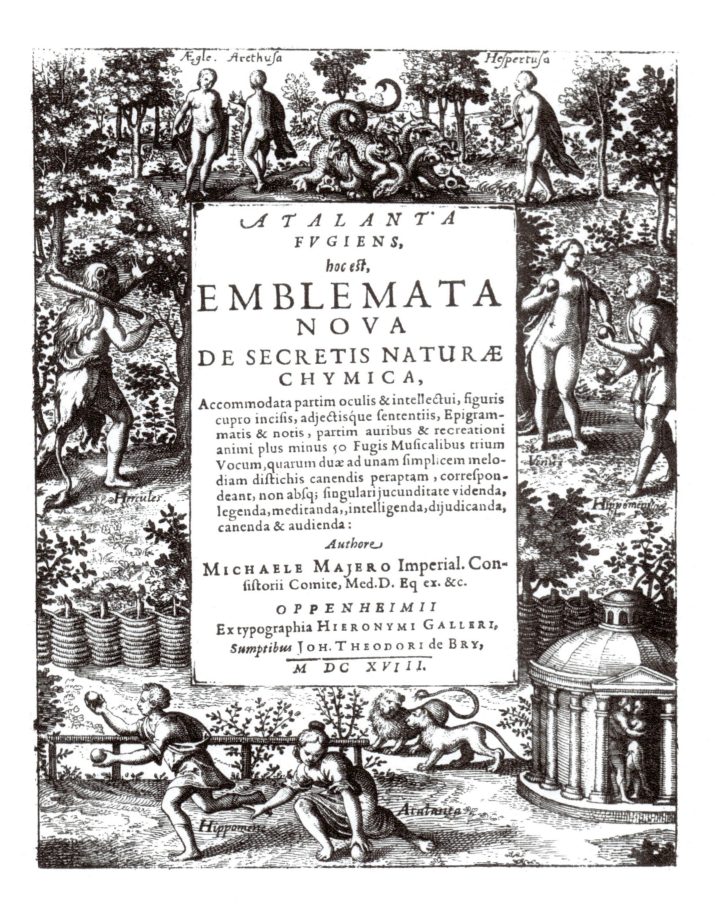

ATALANTA FVGIENS,

hoc est,

EMBLEMATA NOVA DE SECRETIS NATURÆ CHYMICA,

Accommodata partim oculis & intellectui, figuris cupro incisis, adjectisque sententiis, Epigrammatis & notis, partim auribus & recreationi animi plus minus 50 Fugis Musicalibus trium Vocum, quarum duæ ad unam simplicem melodiam distichis canendis peraptam, correspondeant, non absq; singulari jucunditate videnda, legenda, meditanda, intelligenda, dijudicanda, canenda & audienda:

Authore

MICHAELE MAJERO Imperial. Consistorii Comite, Med.D. Eq ex. &c.

OPPENHEIMII
Ex typographia HIERONYMI GALLERI,
Sumptibus JOH. THEODORI de BRY,

M DC XVIII.

Emblem 1

Portavit eum ventus in ventre suo.

The wind bears it in his belly.

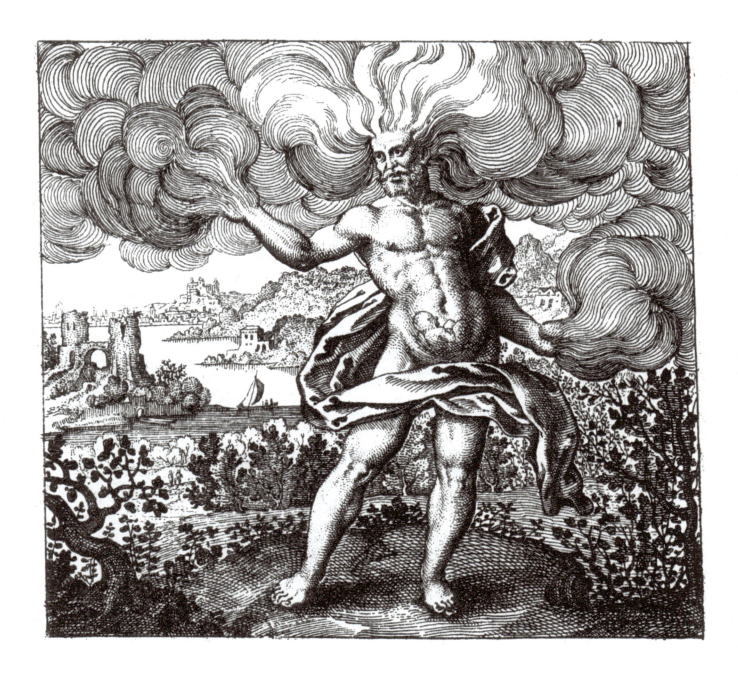

Emblem 2

Nutrix ejus terra est. Its nurse is the earth.

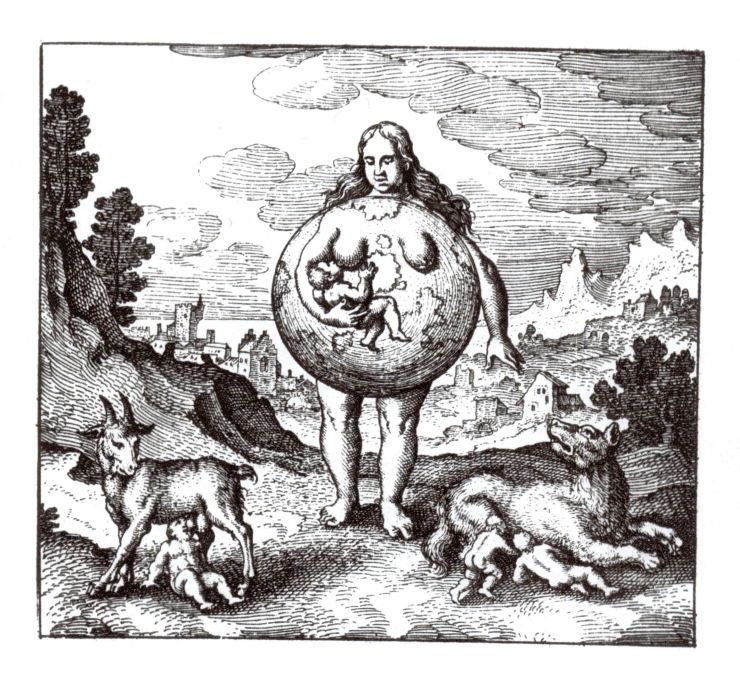

Emblem 3

Vade ad mulierem lavantem pannos,
tu fac similiter.

Go to the woman washing clothes,
and do likewise.

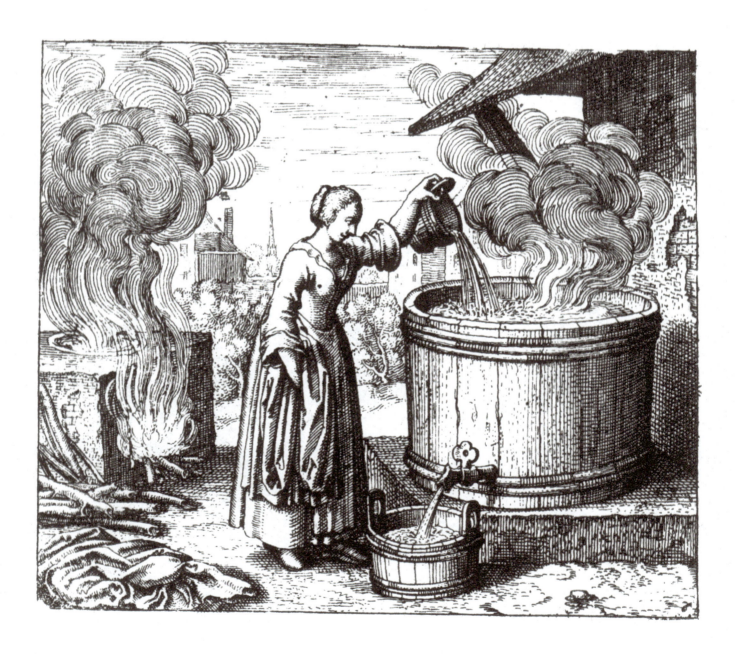

Emblem 4

Conjunge fratrem cum sorore
et propina illis poculum amoris.

Join the brother and sister
and drink to them in the cup of love.

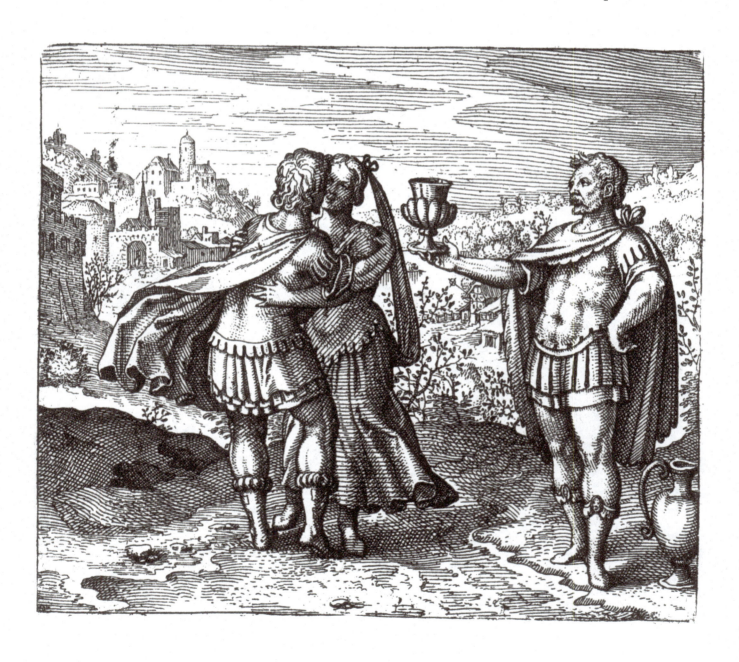

Emblem 5

Appone mulieri super mammas bufonem,
ut ablactet eum, et moriatur mulier,
sitque bufo grossus de lacte.

Put a toad to the woman's breast, that she
may nurse him until she dies,
and he grows large from her milk.

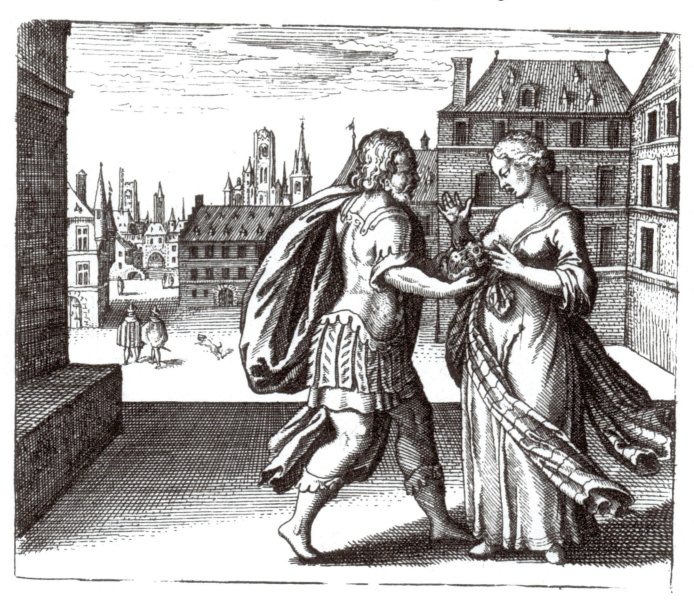

Emblem 6

Seminate aurum vestrum in terram albam foliatam.

Sow your gold in the white foliated earth.

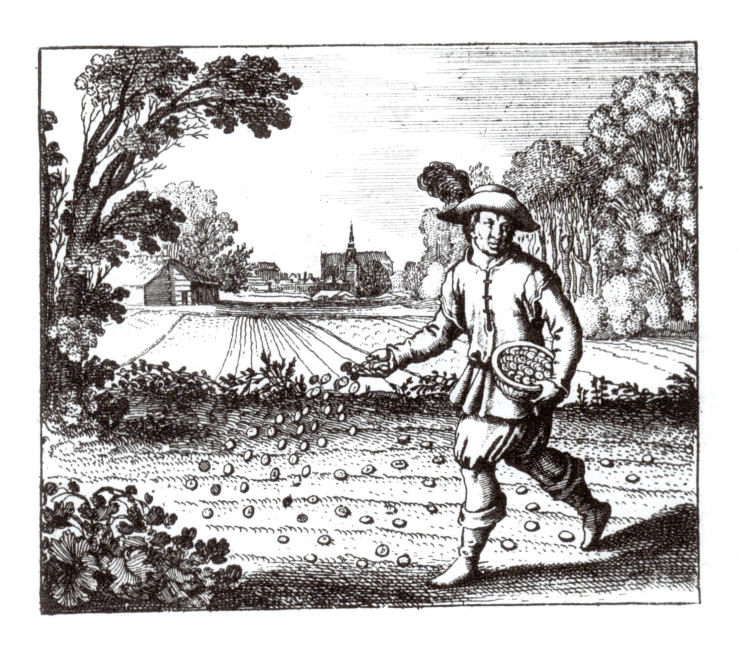

Emblem 7

Fit pullus a nido volans,
qui iterum cadit in nidum.

A young eagle attempts to fly out of its
nest and falls back into it again.

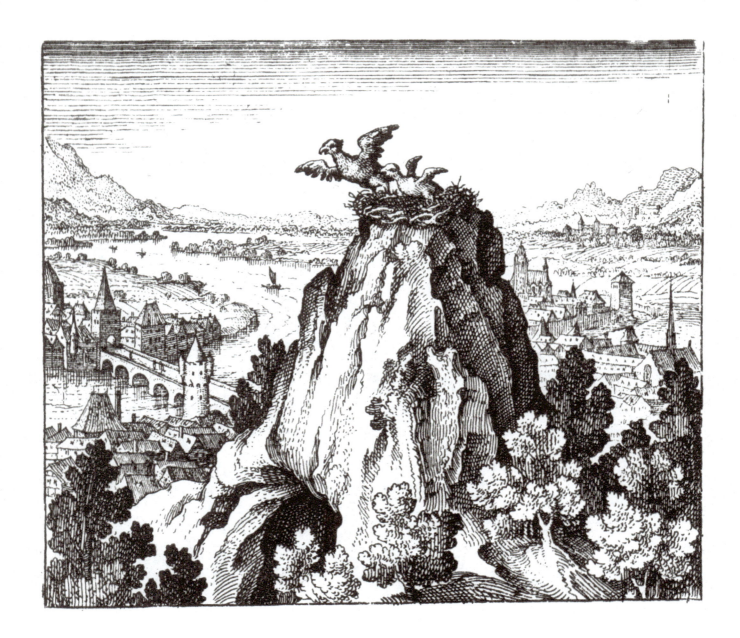

Emblem 8

Accipe ovum et igneo percute gladio.

Take the egg and pierce it with
a fiery sword.

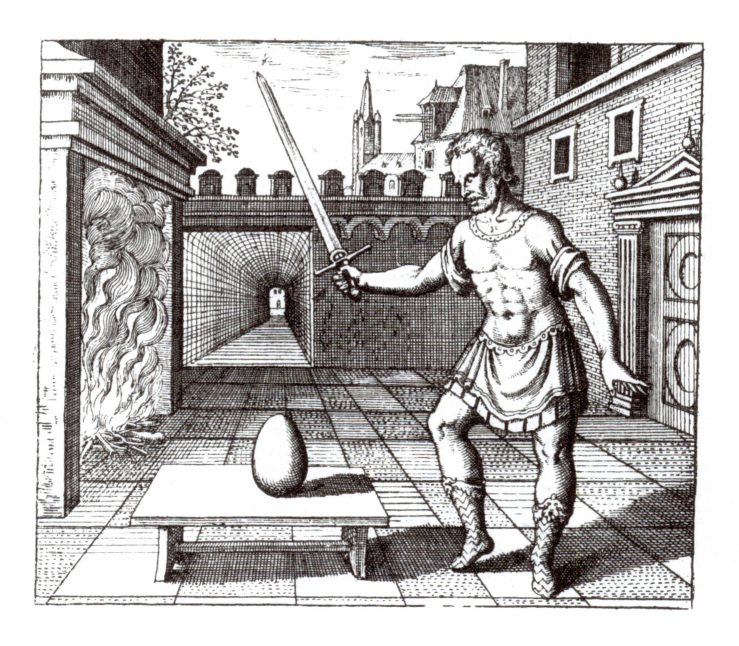

Emblem 9

Arborem cum sene conclude in rorida domo, et comedens de fructu ejus fiet juvenis.

Lock up the tree with the old man in a house of dew, and by eating its fruit he will become young.

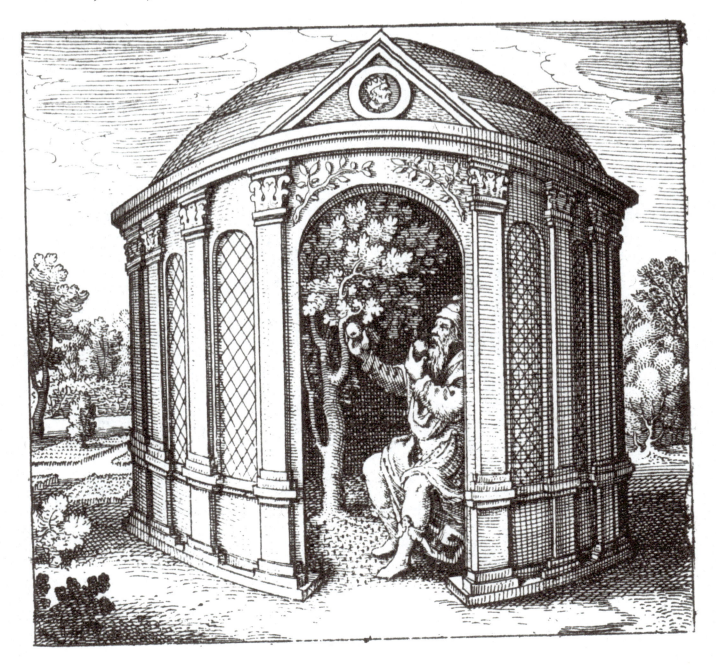

Emblem 10

Da ignem igni, Mercurium Mercurio,
et sufficit tibi.

Give fire to fire, Mercury to Mercury,
and you have enough.

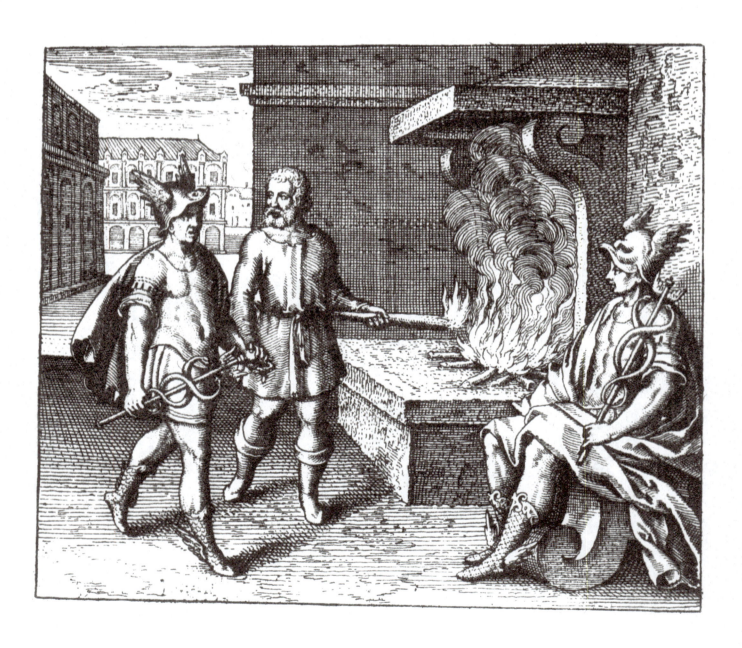

Emblem 11

Dealbate Latonam et rumpite libros. Make Latona white and tear up the books.

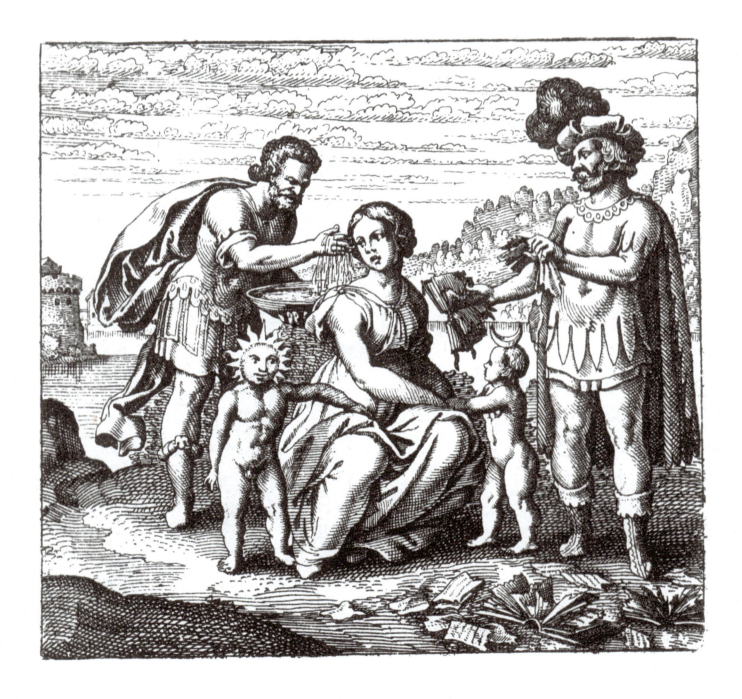

Emblem 12

Lapis, quem Saturnus, pro Jove filio devoratum, evomuit, pro monumento in Helicone mortalibus est postius.

The stone that Saturn devoured instead of his son Jupiter, is vomited up and placed on Helicon as a reminder for mortals.

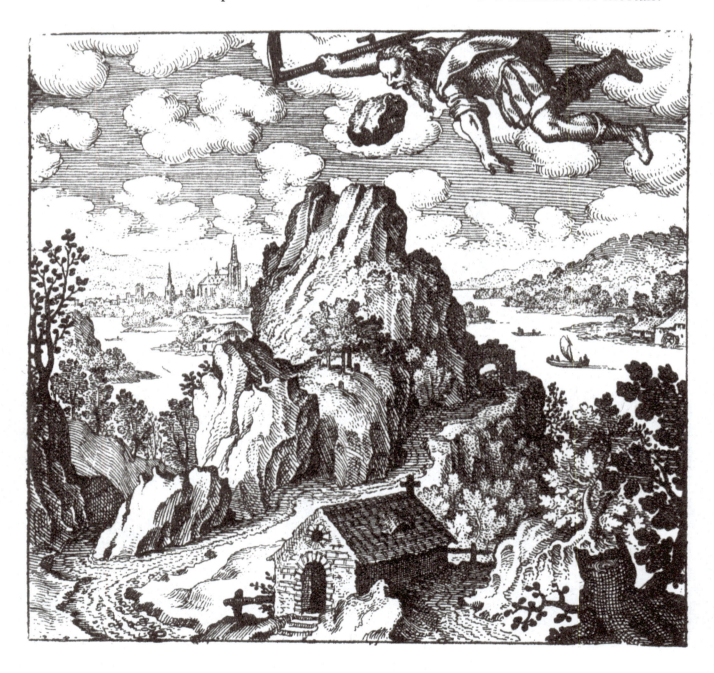

Emblem 13

Aes Philosophorum hydropicum est,
et vult lavari septies in fluvio,
ut Naaman leprosus in Jordane.

The philosophers' brass is dropsical and
wants to be washed seven times in a river,
as Naaman the leper in the Jordan.

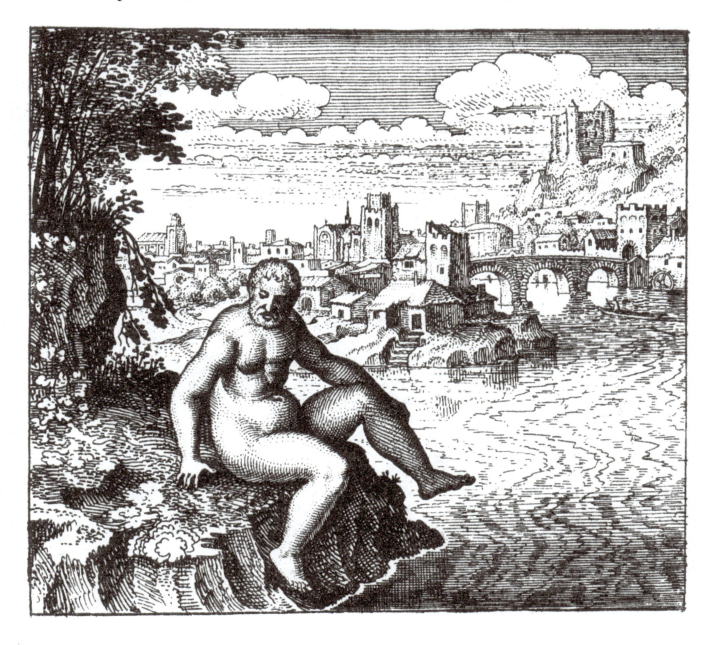

Emblem 14

Hic est Draco caudam suam devorans.

This is the dragon that devours its own tail.

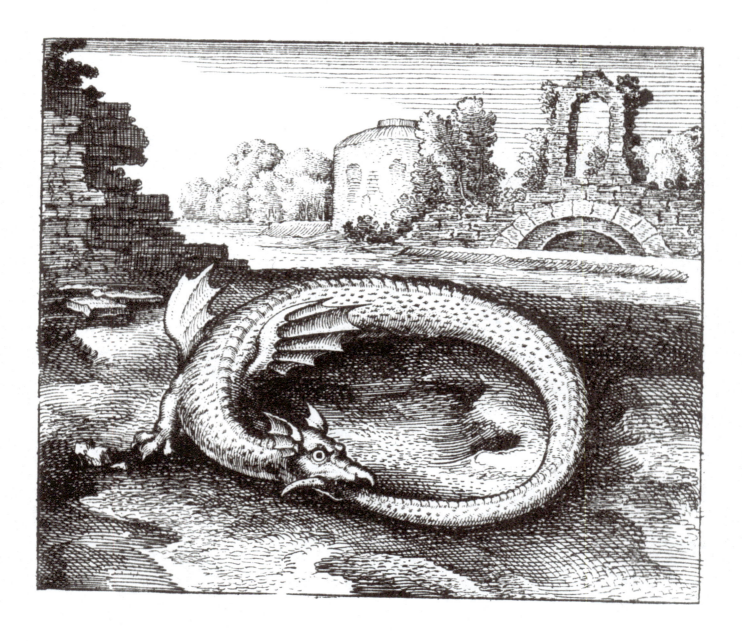

Emblem 15

Opus figuli, consistens in sicco et humido, te doceat.

Let the work of the potter, consisting of dryness and wetness, teach you.

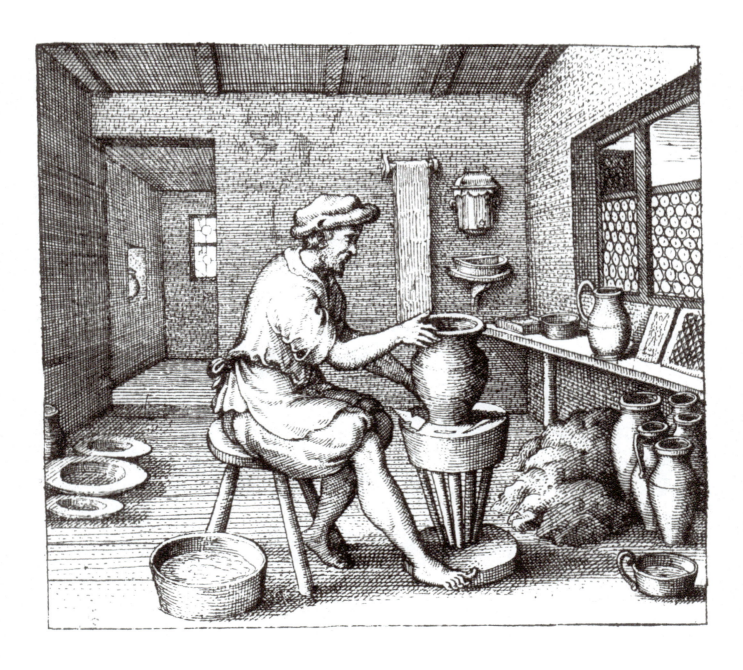

Emblem 16

Hic leo, quas plumas non habet,
alter habet.

This lion has no feathers,
and the other has.

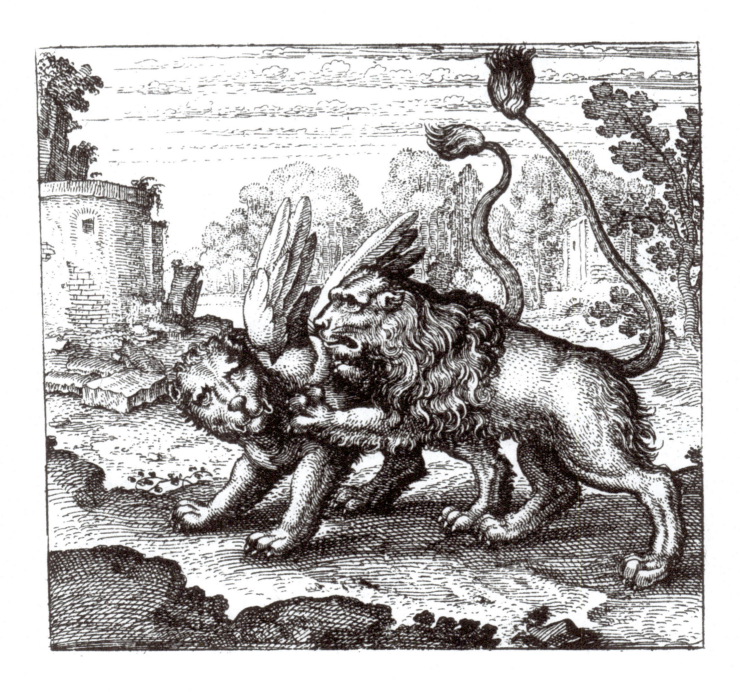

Emblem 17

Orbita quadruplex hoc regit ignis opus. A quadruple sphere rules this work of fire.

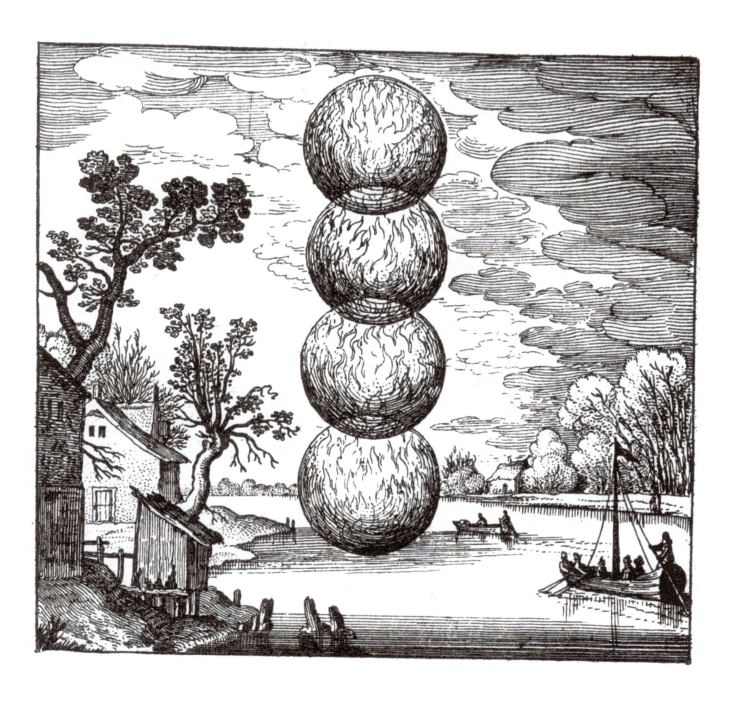

Emblem 18

Ignire ignis amat, non aurificare,
sed aurum.

Fire loves making things fiery,
but unlike gold, it does not make gold.

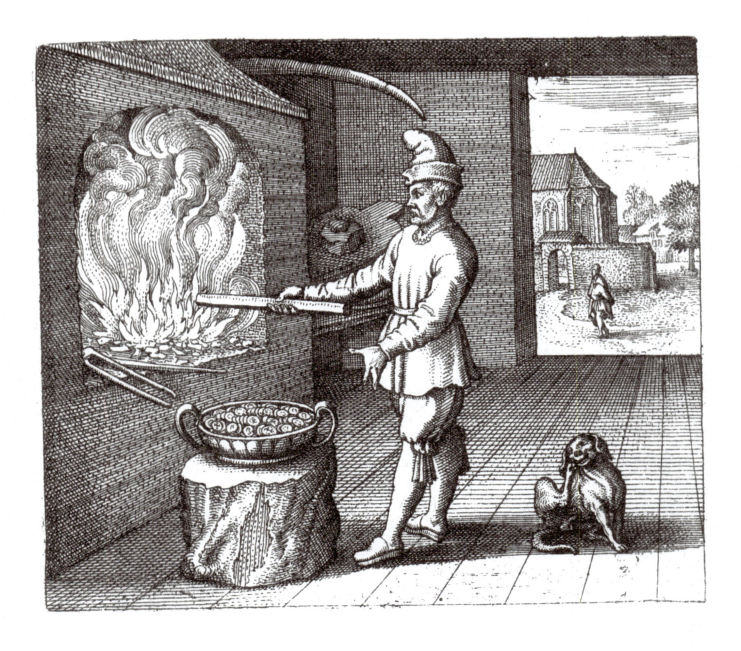

Emblem 19

Si de quattuor unum Occidas,
subito mortuus omnis erit.

If you kill one of the four,
they will all immediately die.

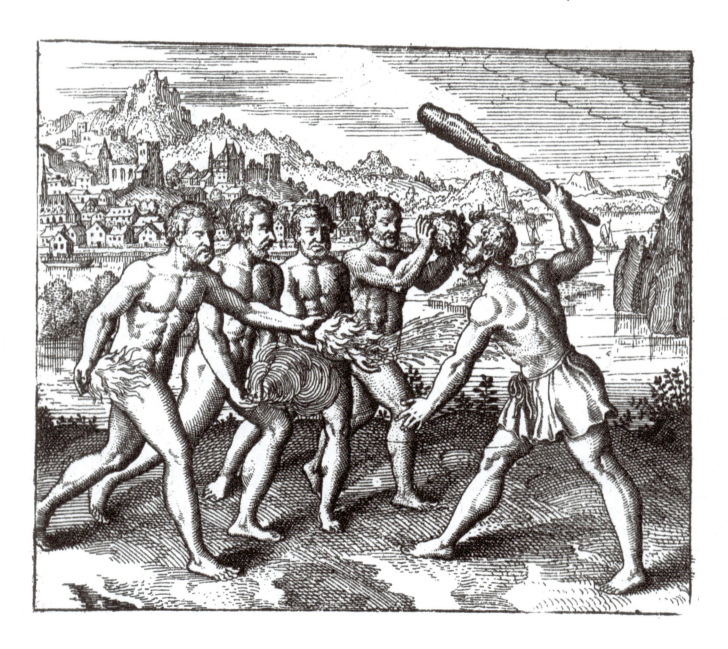

Emblem 20

Naturam natura docet, debellet ut ignem.

Nature teaches nature how to subdue the fire.

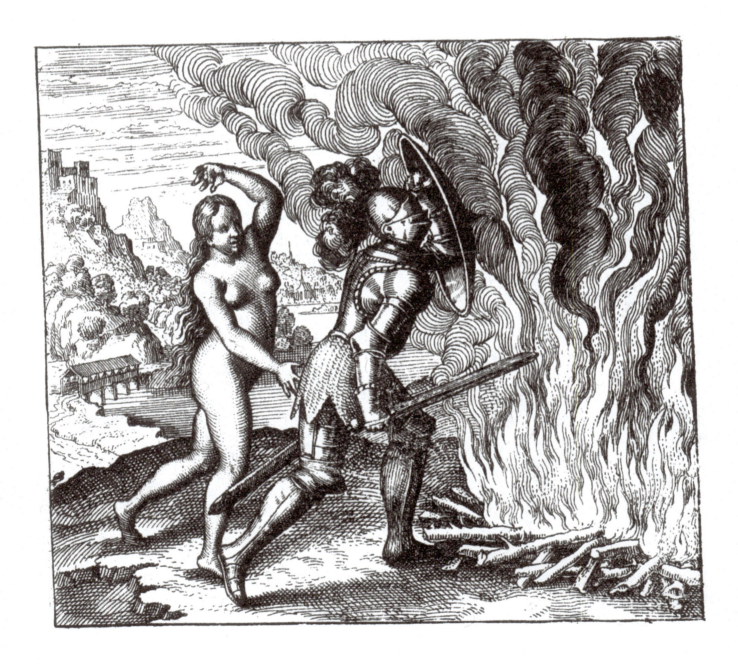

Emblem 21

Fac ex mare et foemina circulum, inde quadrangulum, hinc triangulum, fac circulum et habebis lap. Philosophorum.

Make of man and woman a circle, from that a square, from this a triangle, from that a circle and you will have the philosophers' stone.

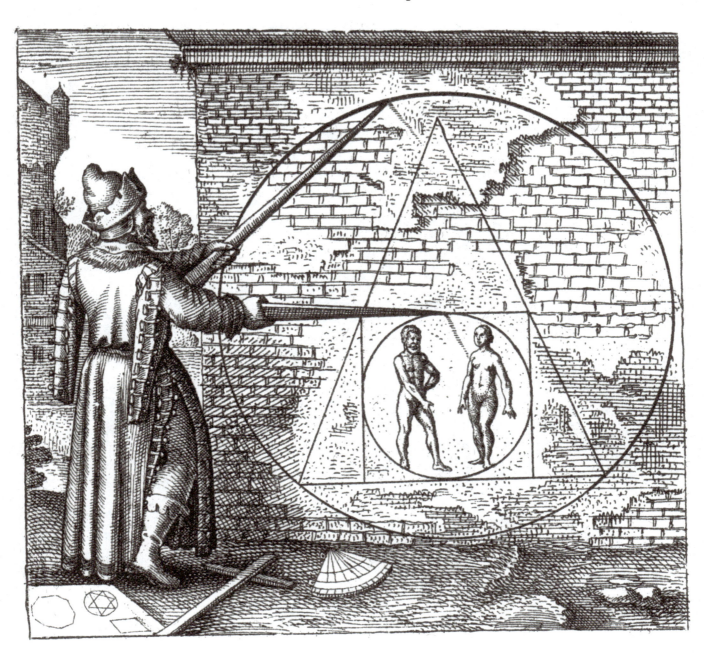

Emblem 22

Plumbo nabito candido fac opus mulierum,
hoc est, COQUE.

Having acquired white lead,
do the women's work, that is, cook.

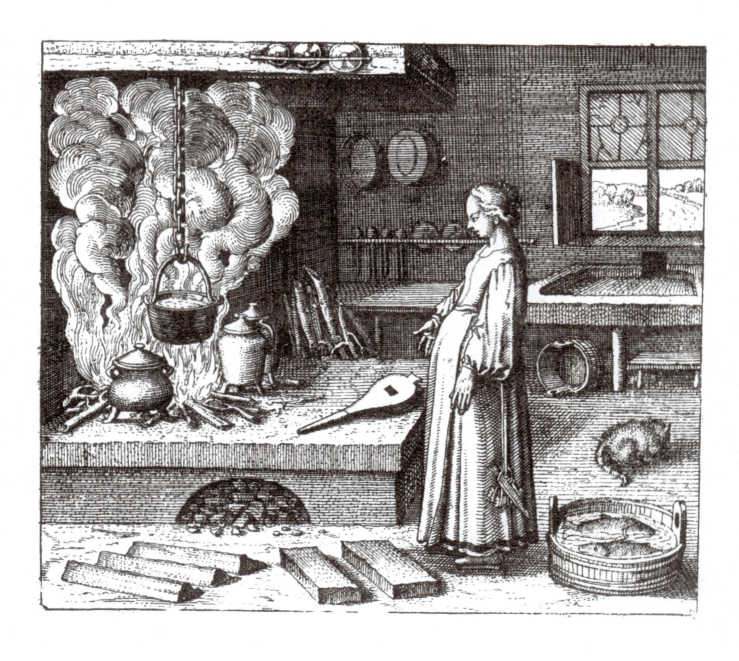

Emblem 23

Aurum pluit, dum nascitur Pallas Rhodi, et Sol concumbit Veneri.

Gold rains down, when Pallas is born at Rhodes, and the sun is in conjunction with Venus.

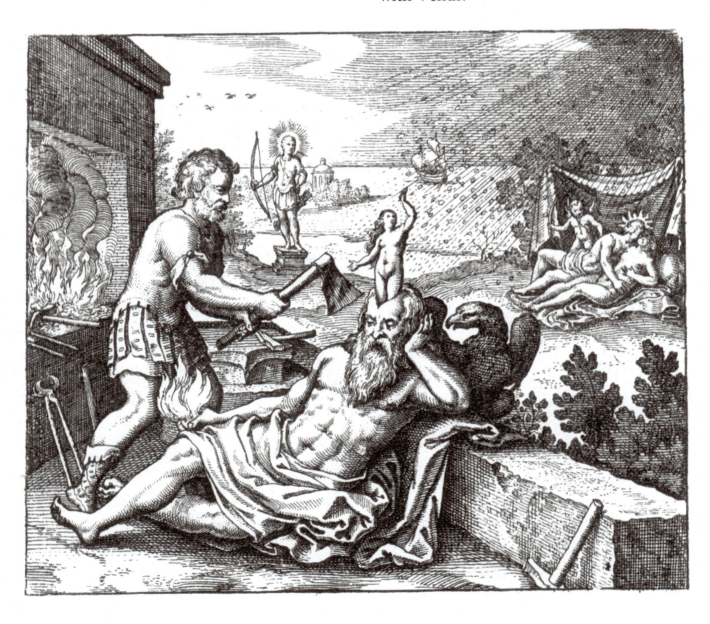

Emblem 24

Regem lupus voravit et vitae crematus reddidit.

A wolf devoured the king, and when burned it restored him to life again.

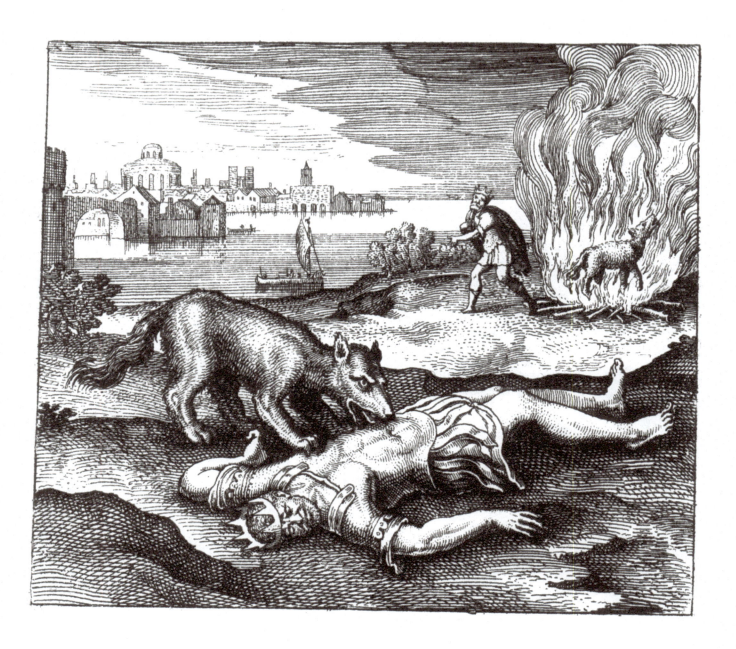

Emblem 25

DRACO non moritur, nisi cum fratre et so-
rore sua interficiatur, qui sunt Sol et Luna.

The dragon does not die unless it is slain
by its brother and sister, who are the sun
and moon.

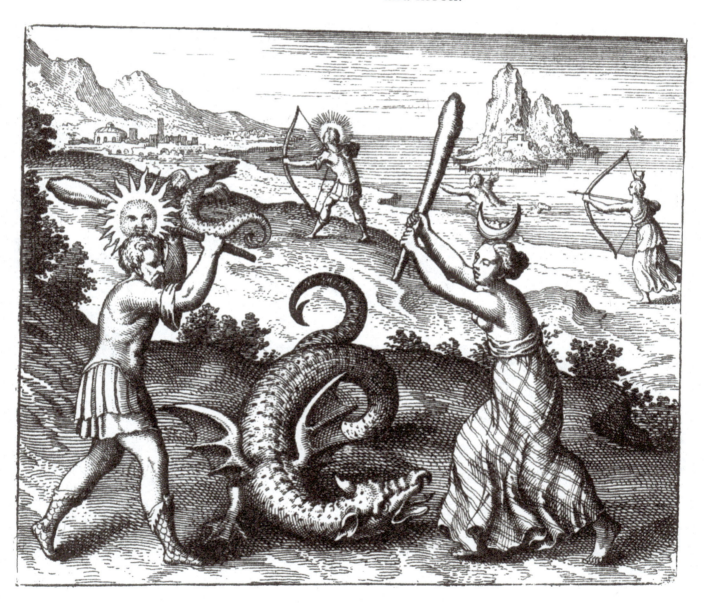

Emblem 26

Sapientiae humanae fructus Lignum vitae est.

The fruit of human wisdom is the tree of life.

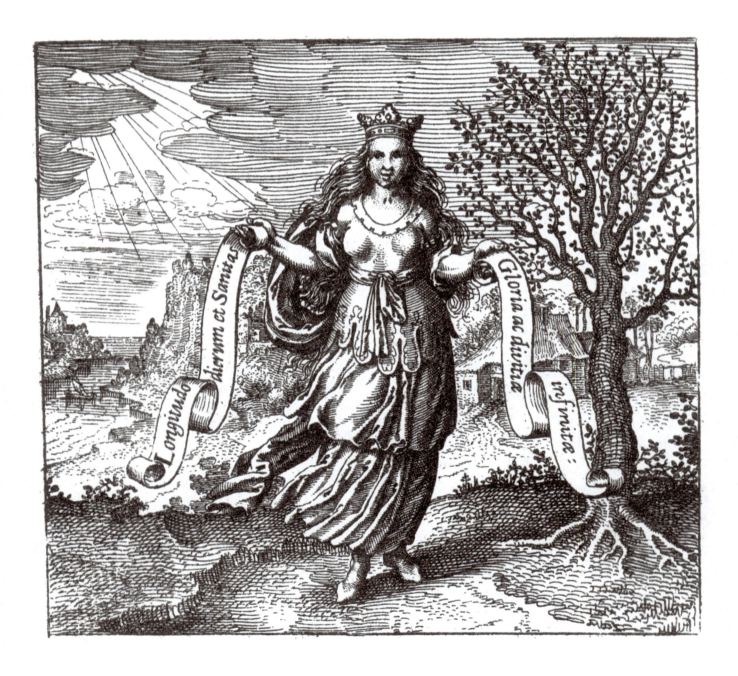

Emblem 27

Qui Rosarium intrare conatur Philoso-
phicum absque clave, assimilatur homini
ambulare volenti absque pedibus.

Whoever wishes to enter into the philoso-
phical rose garden without a key is like a
man who wishes to walk without feet.

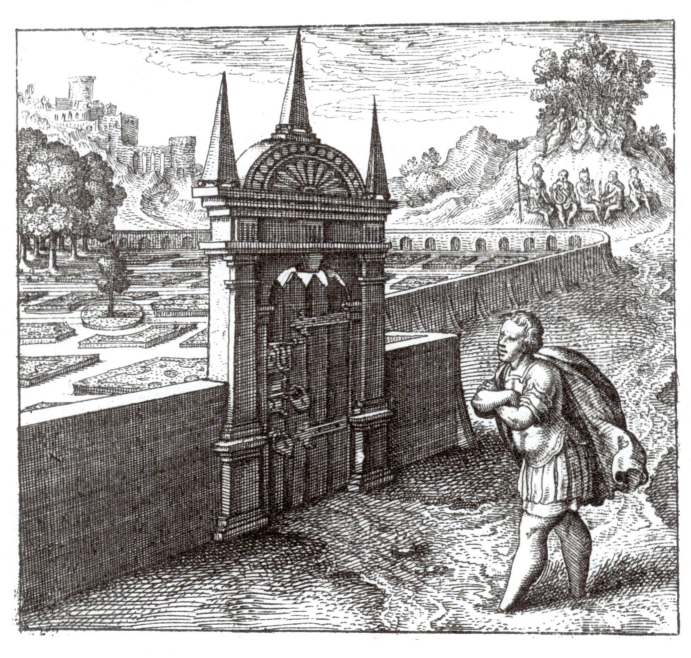

Emblem 28

Rex balneatur in Laconico sedens,
atraque bile liberatur a Pharut.

The king sits in a vaporous bath,
and is freed from the black gall by Pharut.

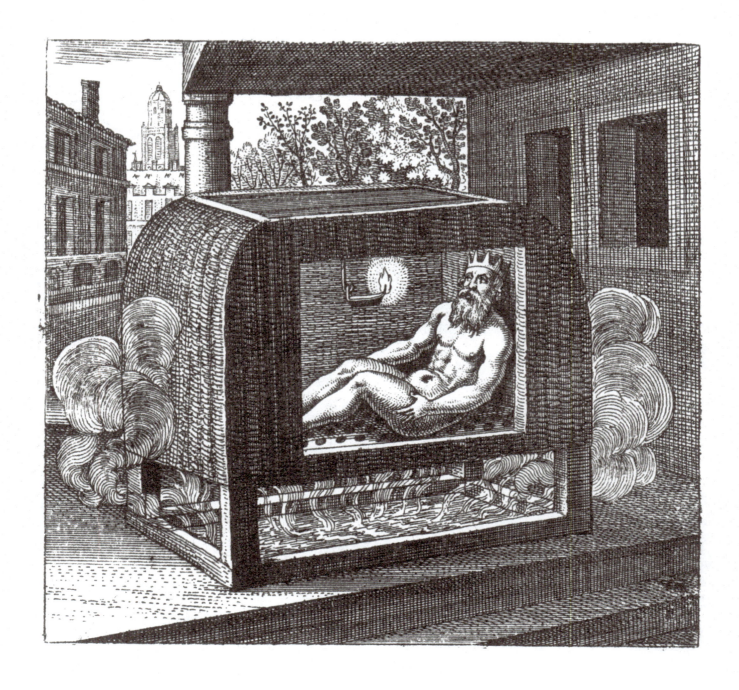

Emblem 29

Ut Salamandra vivit igne sic lapis.

As the salamander lives in fire,
so does the stone.

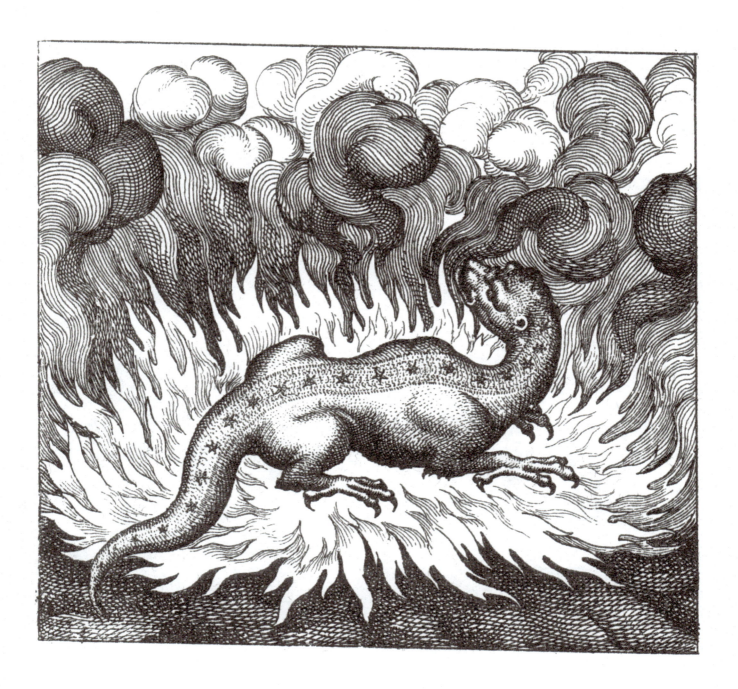

Emblem 30

Sol indiget luna, ut gallus gallina.

The sun needs the moon, like the cock the hen.

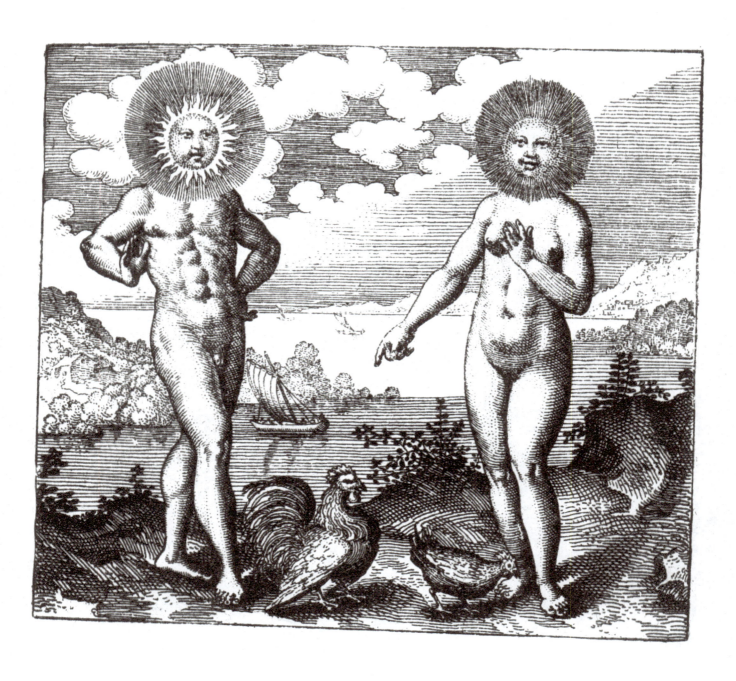

Emblem 31

Rex natans in mari, clamans alta voce:
Qui me eripiet, ingens praemium habebit.

The king swimming in the sea cries out with a loud voice: whoever rescues me will have a great reward.

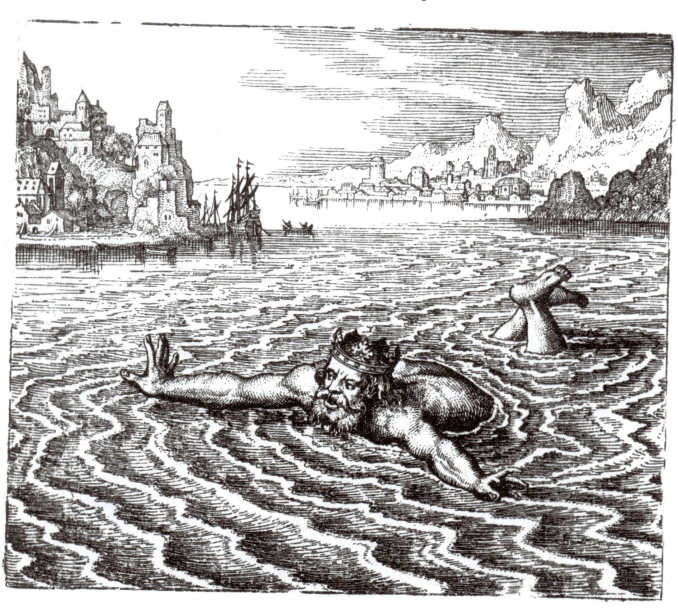

Emblem 32

Corallus sub aquis ut crescit et aere indura-
tur, sic lapis.

As coral grows under water and is hard-
ened by the air, so does the stone.

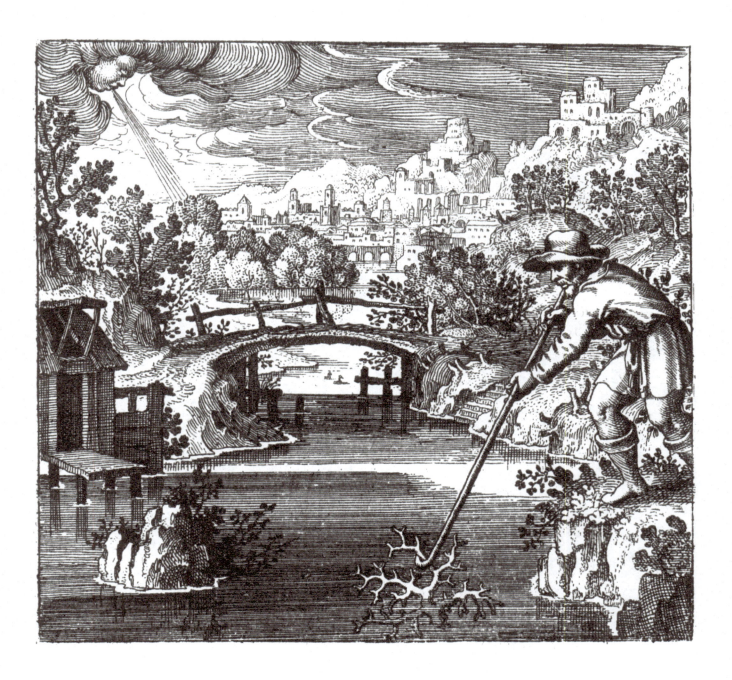

Emblem 33

Hermaphroditus mortuo similis, intenebris jacens, igne indiget.

The hermaphrodite, lying like a corpse in darkness, needs fire.

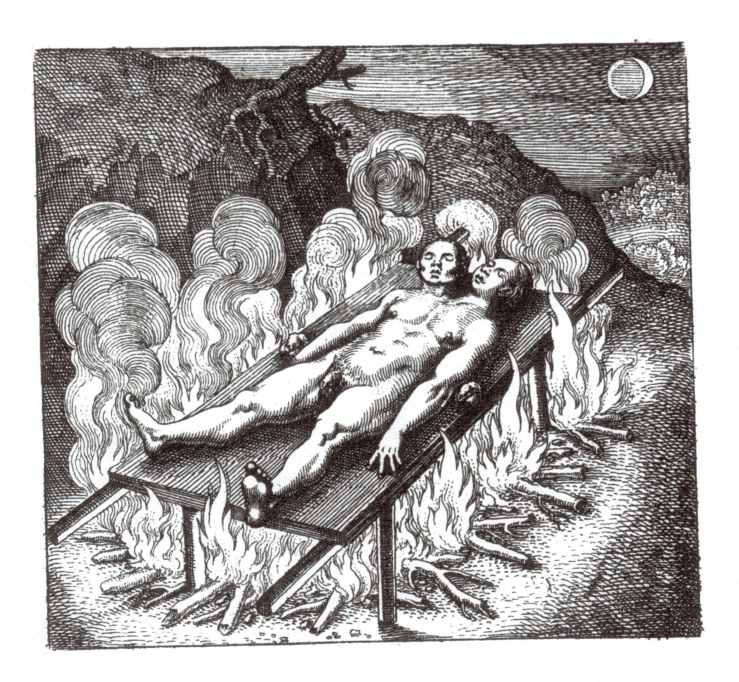

Emblem 34

In balneis concipitur, et in aere nascitur,
rubeus vero factus graditur super aquas.

He is conceived in the bath, born in the
air, and when he turns red he walks above
the waters.

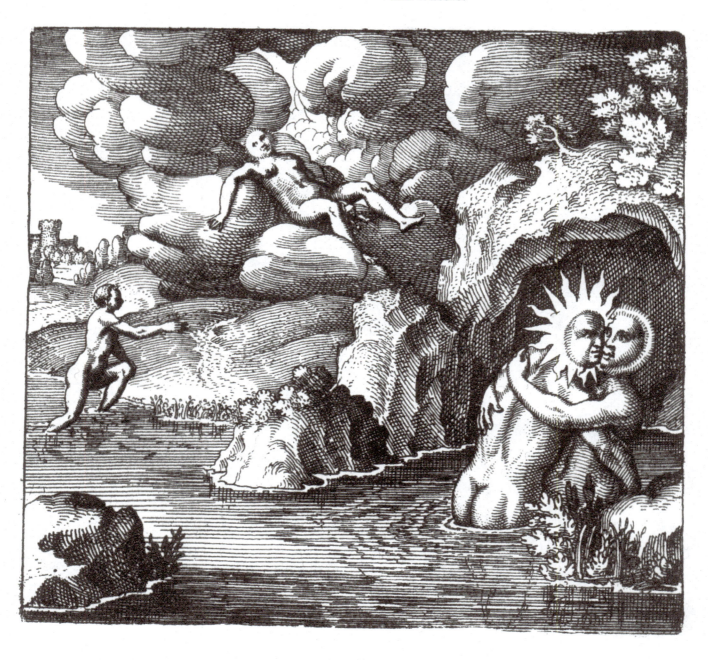

Emblem 35

Ceres Triptolemum, Thetis Achillem,
ut sub igne morari assuefecit,
sic artifex lapidem.

As Ceres adapted Triptolemus and
Thetis adapted Achilles to stay in the fire,
so the artist does to the stone.

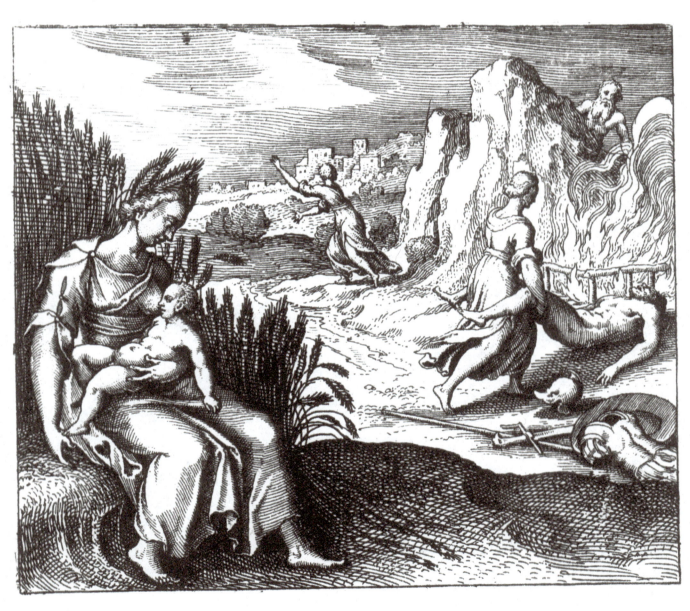

Emblem 36

Lapis projectus est in terras, et in montibus exaltatus, et in aere habitat, et in flumine pascitur, id est, Mercurius.

The stone is cast upon the earth, exalted in the mountains, resides in the air, and is nourished in the waters, that is, Mercury.

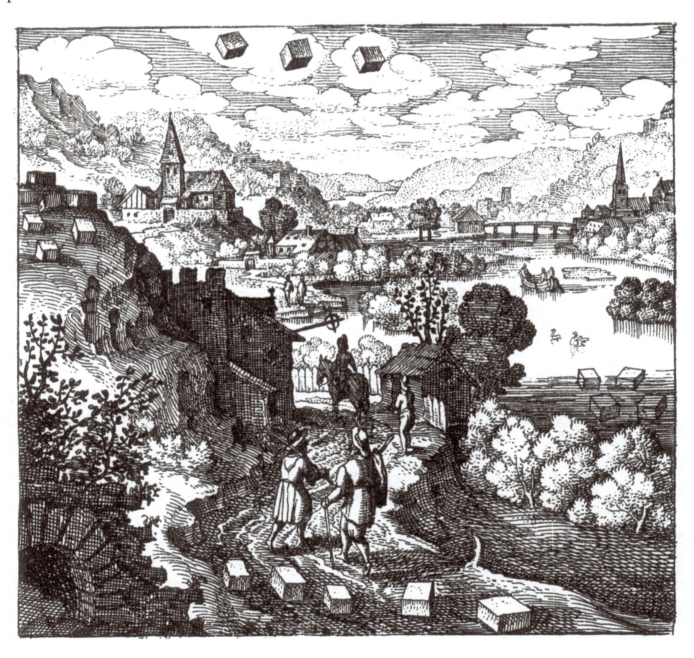

Emblem 37

Tria sufficiunt ad magisterium, fumus al-
bus, hoc est, aqua, leo viridis, id est, aes
Hermetis, et aqua foetida.

Three things sufficient for the mastery
are the white smoke that is water,
the green lion that is the brass of Hermes,
and fetid water.

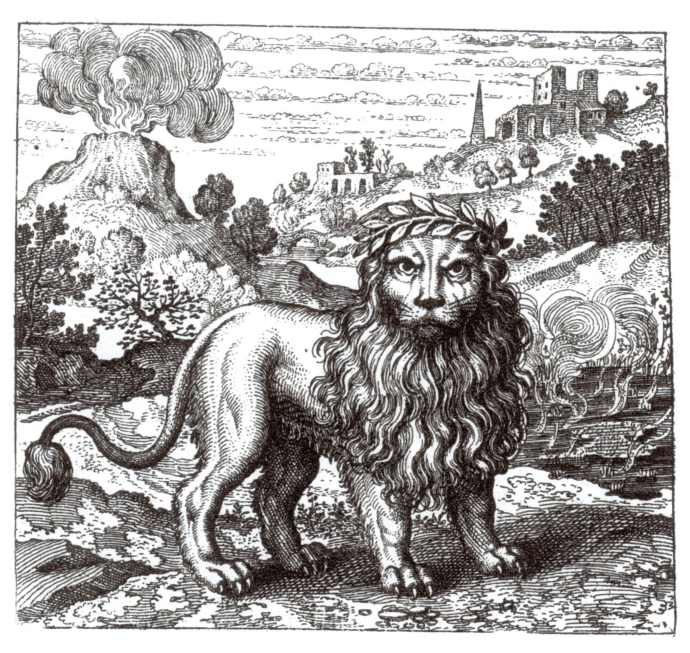

Emblem 38

Rebis, ut Hermaphroditus, nascitur ex duobus montibus, Mercurii et Veneris.

Rebis, like a hermaphrodite, is born from the two mountains of Mercury and Venus.

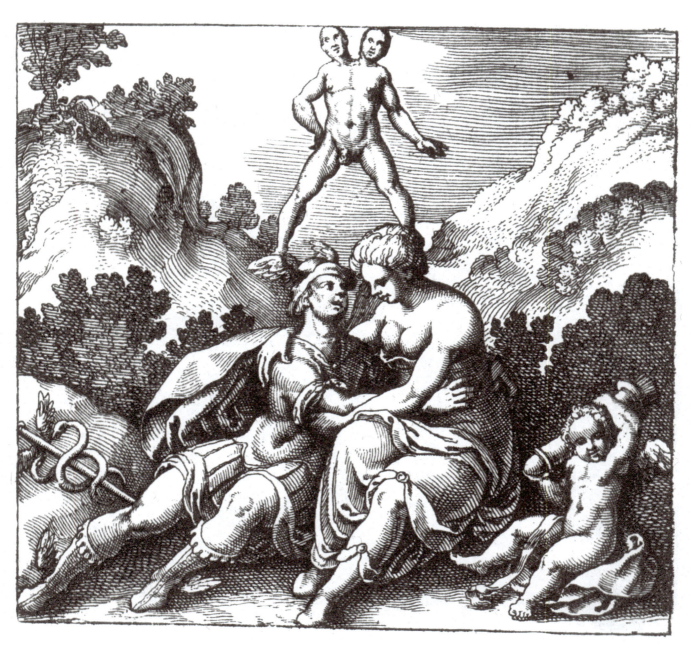

Emblem 39

Oedypus Sphynge superata et trucidato
Lajo patre matrem ducit in uxorem.

Oedipus, having overcome Sphinx and
killed his father Laius, marries his mother.

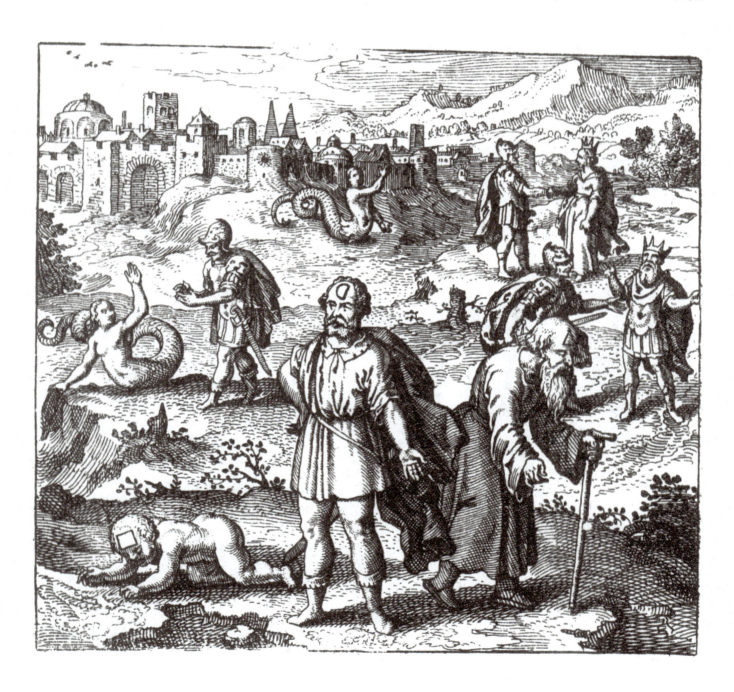

Emblem 40

Ex duabus aquis, fac unam,
et erit aqua sanctitatis.

Out of two waters make one,
and it will be the water of holiness.

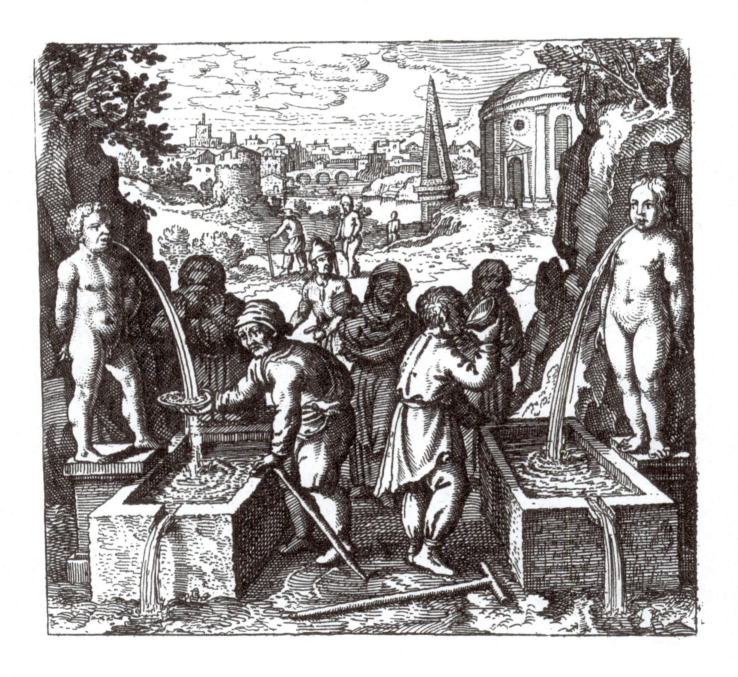

Emblem 41

Adonis ab apro occiditur,
cui Venus accurrens tinxit Rosas sanguine.

Adonis is killed by a boar,
behind which Venus hastens
and tinctures the roses with her blood.

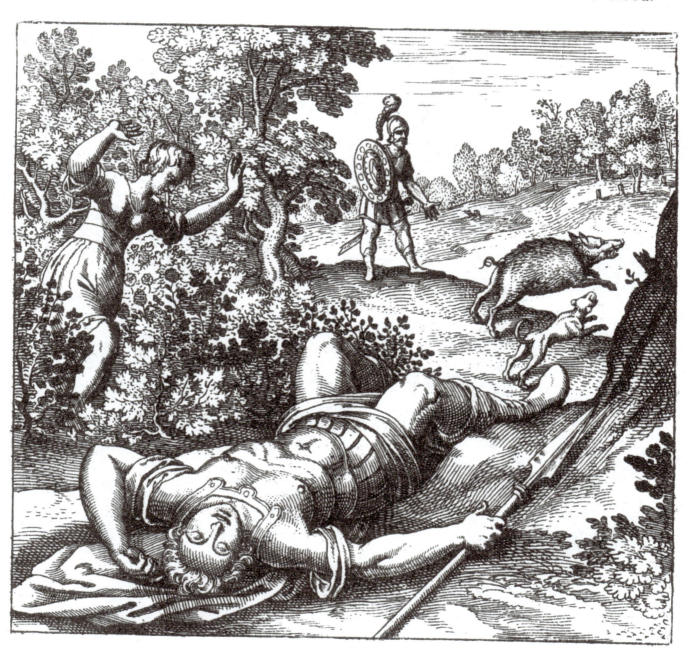

Emblem 42

In Chymicis versanti Natura, Ratio,
Experientia et lectio, sint Dux, scipio,
perspicilia et lampas.

For him who is versed in chemistry, let
nature, reason, experience, and reading be
his guide, staff, spectacles, and lantern.

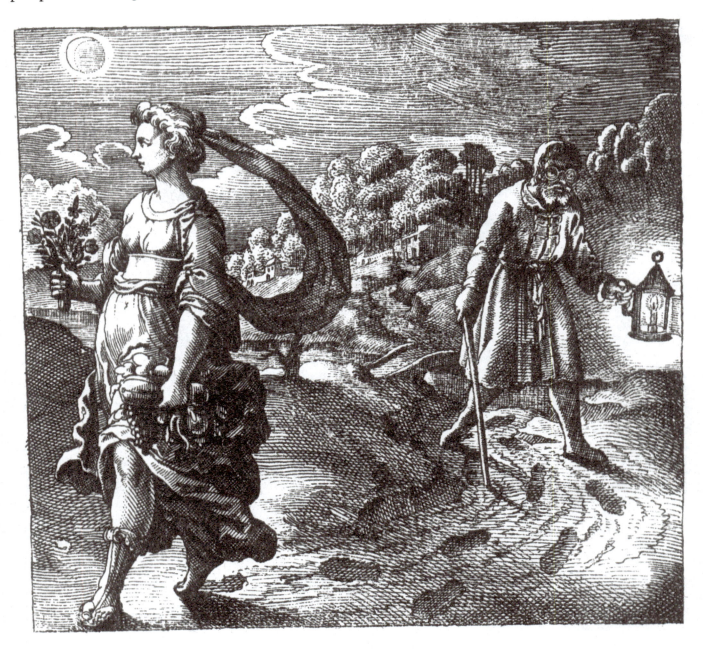

Emblem 43

Audi loquacem vulturem,
qui ne utiquam te decipit.

Listen to the words of the vulture,
which in no way deceves you.

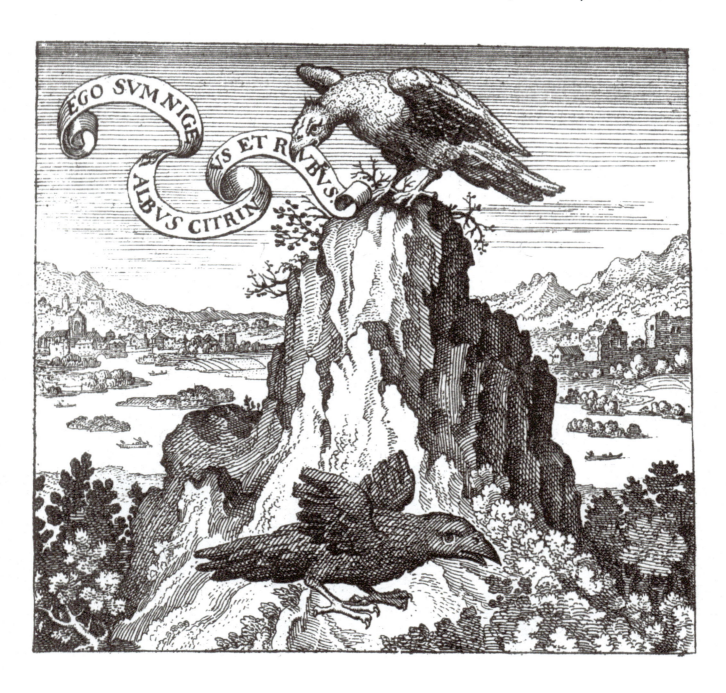

Emblem 44

Dolo Typhon Osyridem trucidat,
artusque illius hinc inde dissipat,
sed hos collegit Isis inclyta.

Typhon kills Osiris by deceit,
and afterwards scatters his limbs,
but the famous Isis gathers them together.

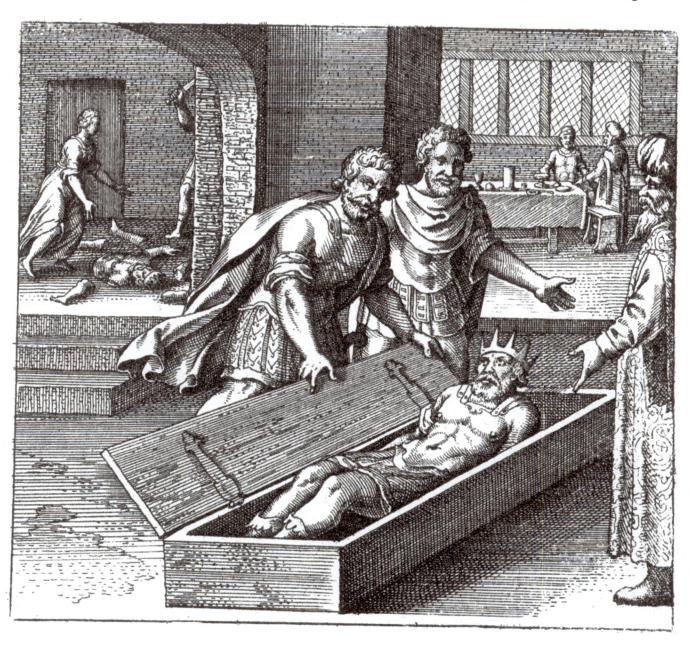

Emblem 45

Sol et ejus umbra perficiunt opus.

The sun and its shadow complete the work.

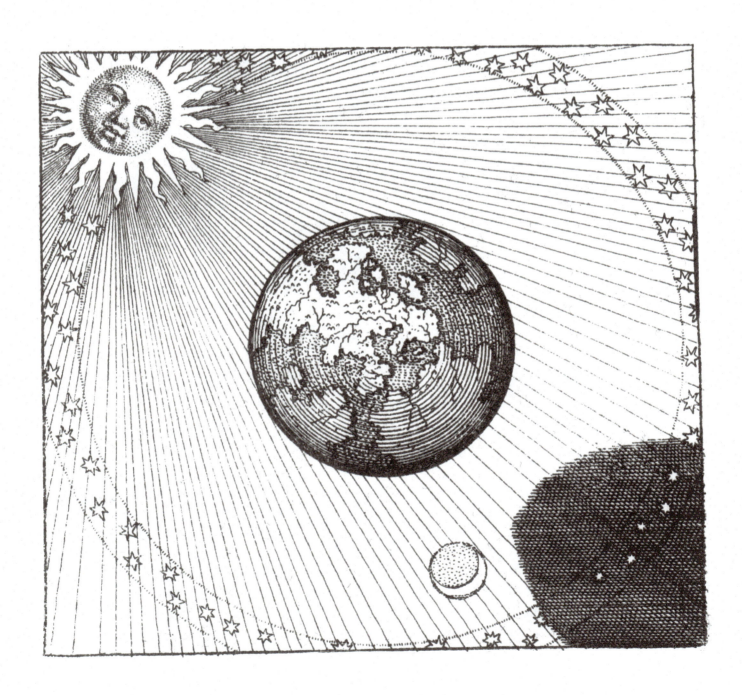

Emblem 46

Aquilae duae, una ab ortu,
altera ab occasu conveniunt.

Two eagles come together, one from the
east, the other from the west.

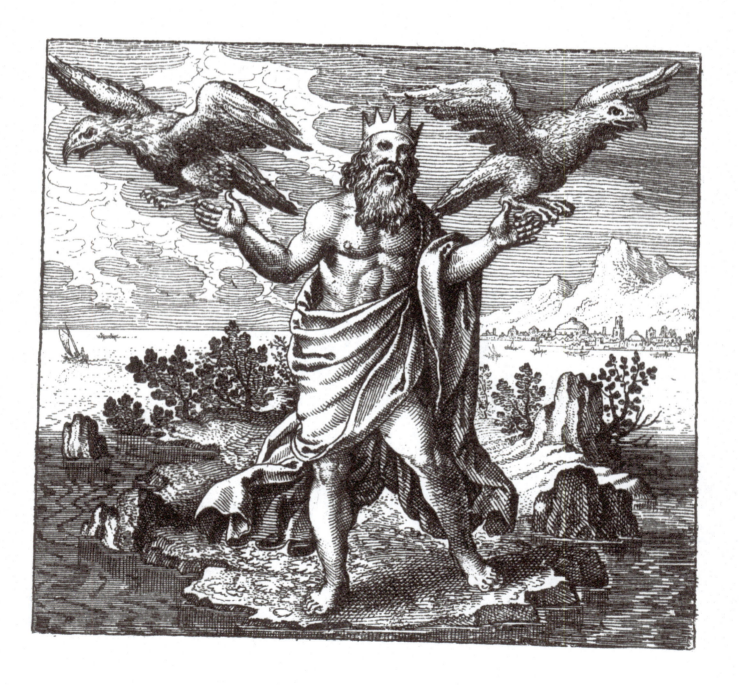

Emblem 47

Lupus ab Oriente et Canis ab Occidente venientes se invicem momorderunt.

The wolf from the east and the dog from the west have bitten each other.

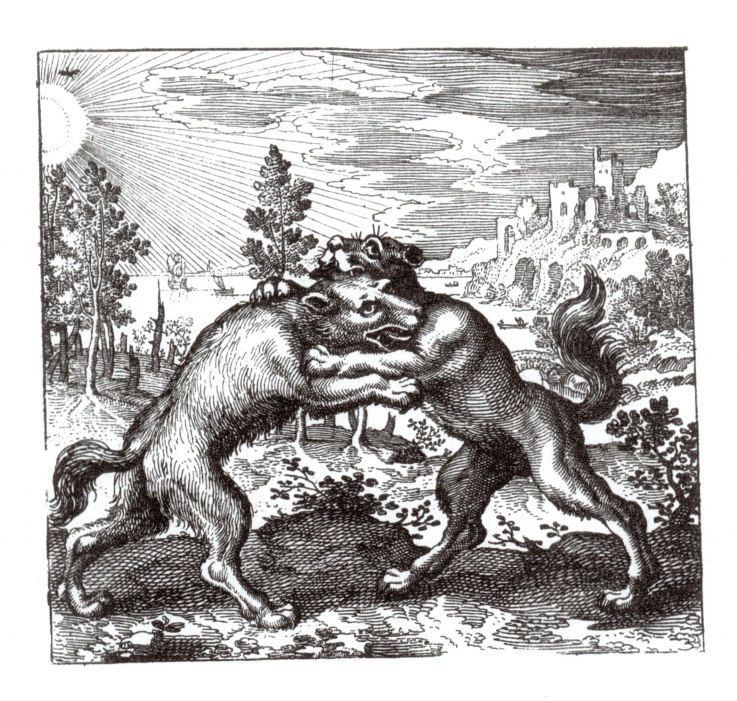

Emblem 48

Rex ab aquis potatis morbum,
a medicis curatus sanitatem obtinet.

The king, sick from drinking the waters,
is cured by the physicians and regains
his health.

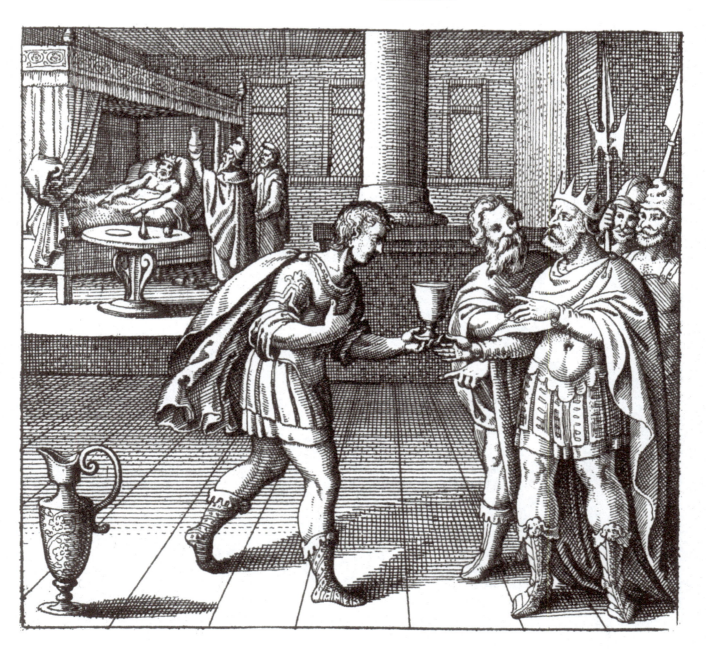

Emblem 49

Infans Philosophicus tres agnoscit patres,
ut Orion.

The philosophical child acknowledges
three fathers, like Orion.

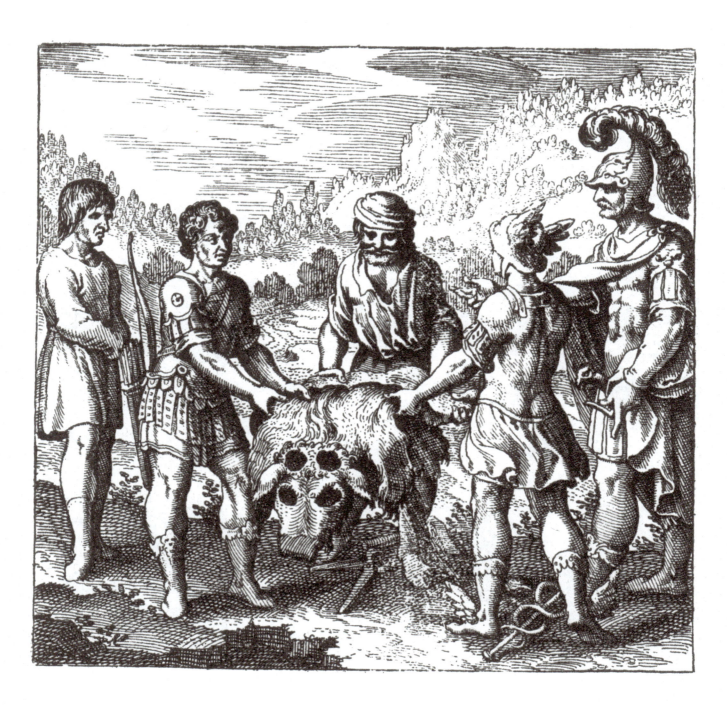

Emblem 50

Draco mulierem, et haec illum interimit, simulque sanguine perfunduntur.

The dragon kills the woman, and she kills it, and both soak in blood.

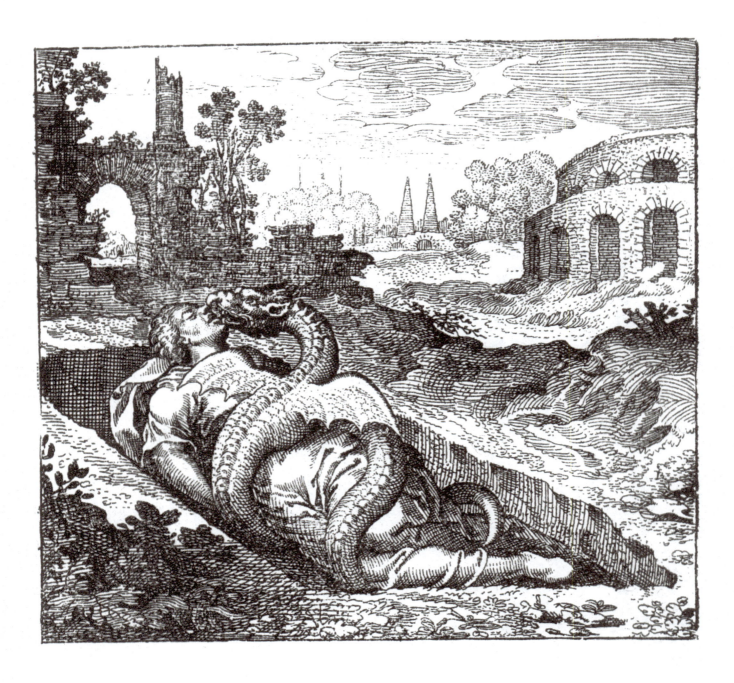

Michael Maier (1596-1622)

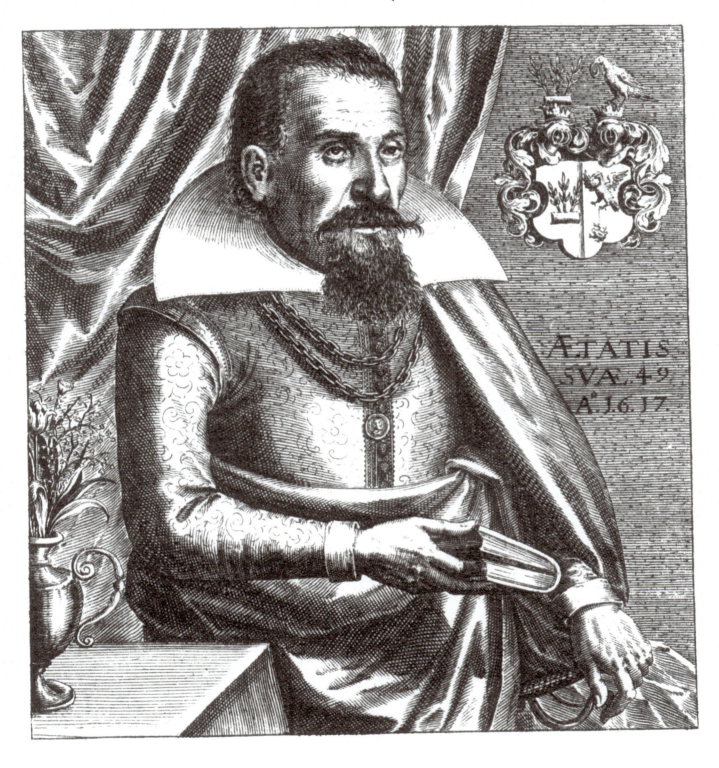

ÆTATIS
SVÆ 49
Aᵒ 16 17